❄ BAR MITZVAH ❄

BAR MITZVAH

Story by DAVID MAMET

Drawings by DONALD SULTAN

A BULFINCH PRESS BOOK

LITTLE, BROWN AND COMPANY
Boston · New York · London

First Edition

ISBN 0-8212-2546-4

Library of Congress Catalog Number 98–74452

Bulfinch Press is an imprint and trademark of Little, Brown and Company (Inc.)

Design by Jerry Kelly

Printed in Hong Kong

✻ BAR MITZVAH ✻

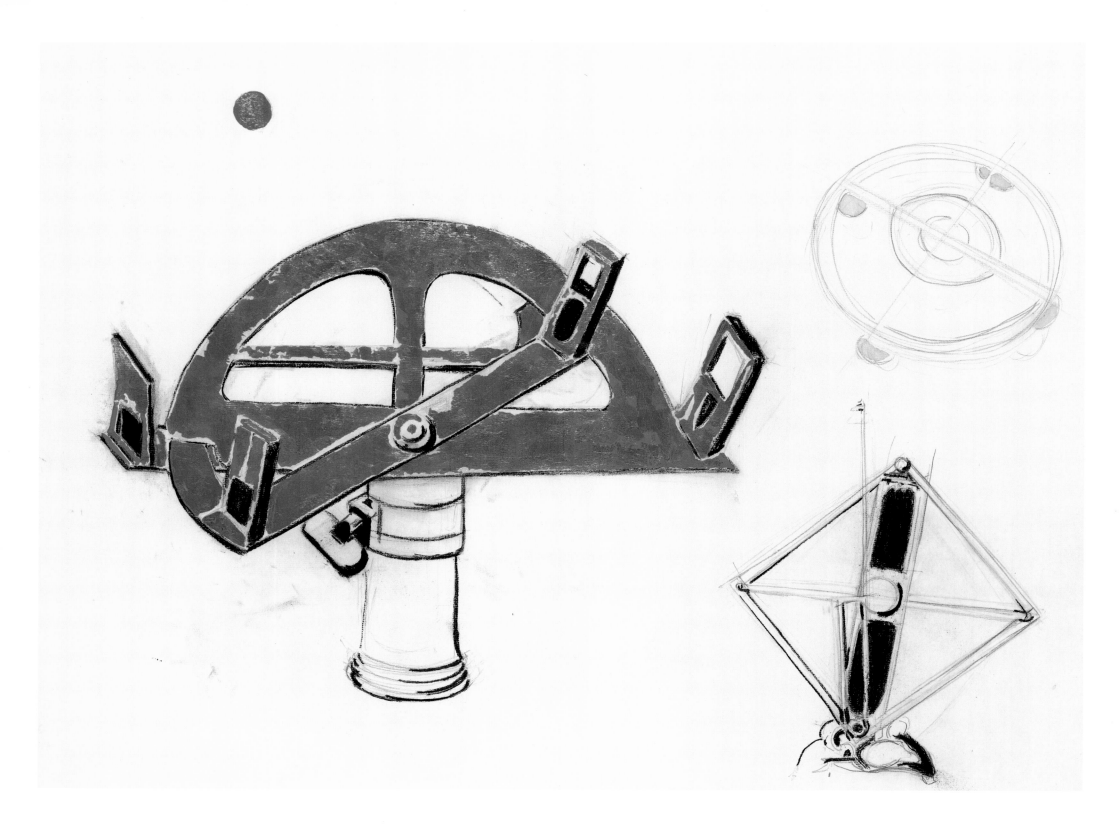

Topographical Instruments

W ELL, YOU SEE," THE OLD MAN SAID, "these parts are going to be worth something someday. It used to be that we would meet and trade—who had an escapement for a certain watch, who had a flywheel; or, if none were to be had, who had the expertise, or who had the tools, do you see, to *make* one.

"We would exchange *suggestions* —" He paused for a moment.

HE BREATHED HEAVILY, and his breath sounded occluded, and heavy in his throat. "Well, that knowledge is going to be gone," he said. "Perhaps five hundred years of clock making—ah, here is an interesting piece—this is a *contrivance*," he said, "for the movement of a watch. Made in the twenties. And I ask you to look at the variation in color, these two 'metal pieces,' here, you see that?"

"Yes," the boy said.

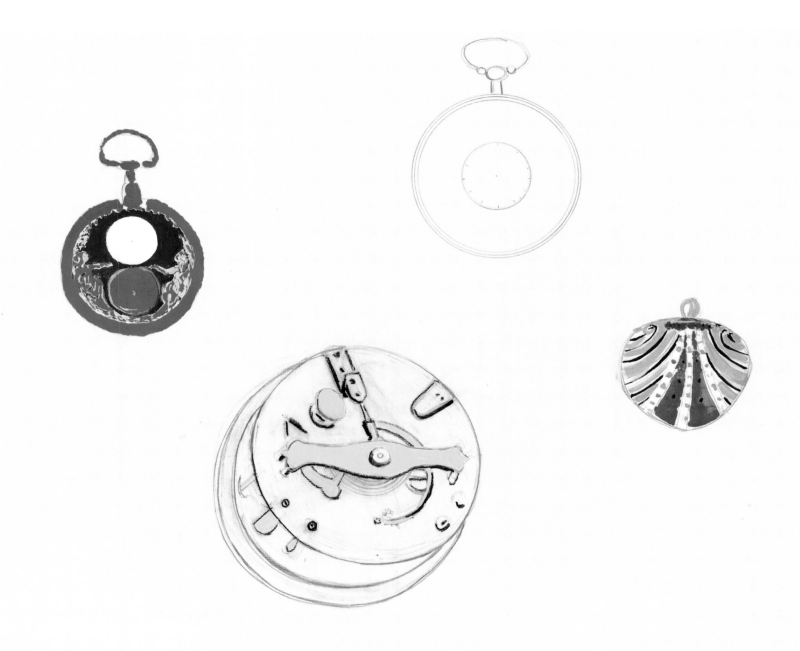

Watches

CAN YOU THINK WHY THAT WOULD BE? I'm going to tell you. For years men labored to understand and to *surmount* the problem raised by the expansion of metals—their expansion and contraction. *Summer*, they would"—he spread his arms apart—"and Winter. . .What does that do to the movement of a watch?

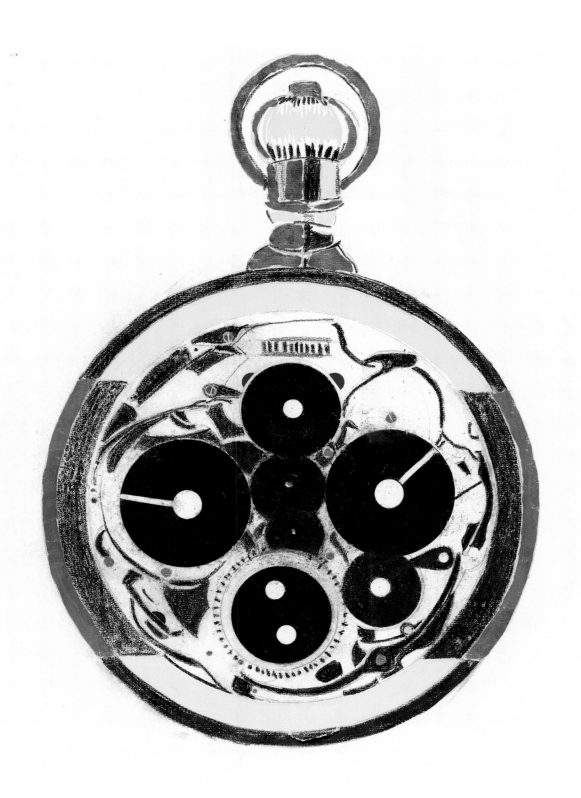

Watch Interior

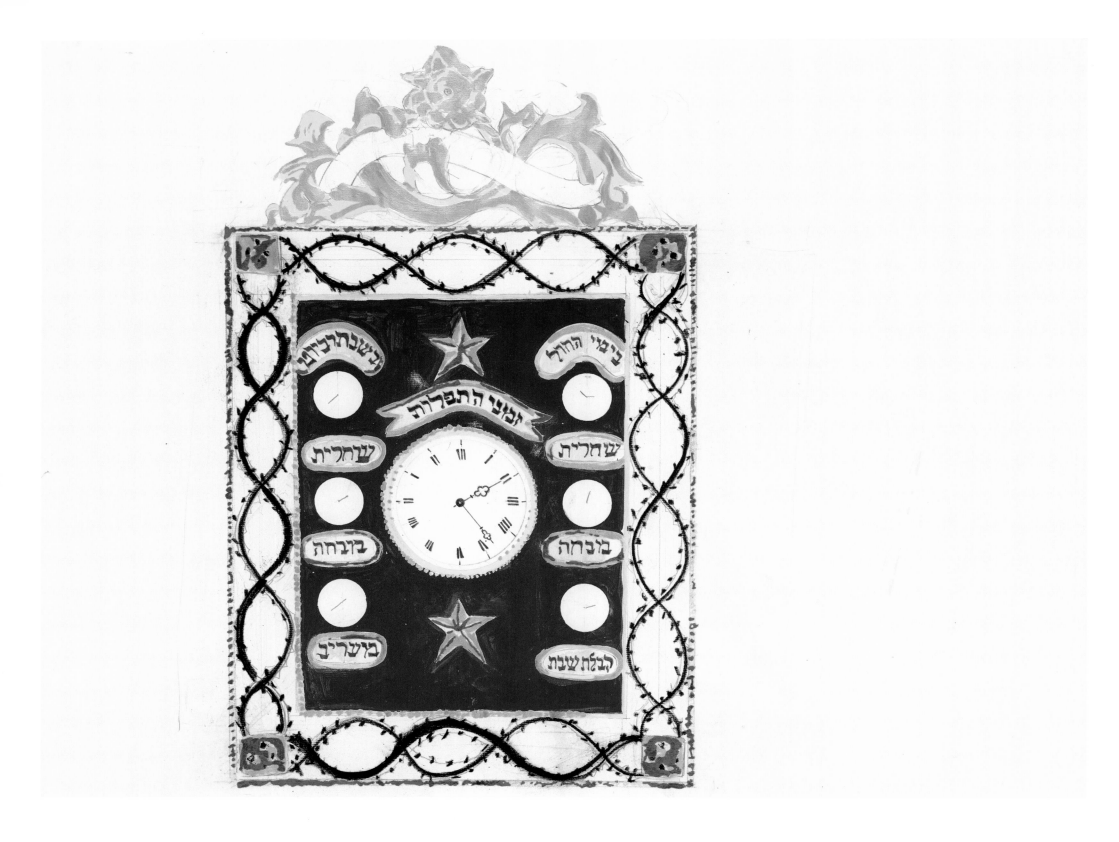

Synagogue Clock

THE WATCH IS MADE OF METAL. Must that not affect the running of the watch? Of course it does. And in the Summer, the old watch will run faster, and in the Winter it slows. So, for years watchmakers strove with this 'deep problem.'

"Till one man, I would tell his name to you if I remembered it, devised a watch whose *weights* were made of differing metals, which contracted at differing rates, and so designed it that it would not vary, one season to the next, from the expansion of the *metal*" – he corrected himself– "it would, of course, vary from different causes."

"What causes would those be?" the boy asked.

THE MAN NODDED APPROVINGLY.

"Any mechanical movement, you see, is a poem. It is like a poem, which, they said, is never completed—only abandoned. The finer you make your pieces, in the quest for precision, the more likely they are to wear. The more intricate your movement in the search for accuracy, the more friction you introduce; and, overall, you have the bothersome conundrum of a *spring*, which is wound, and will unwind at an uneven rate, powering an engine whose purpose, whose sole purpose, is to demark a regular interval.

"Which is why I applaud the automatic movement, where, in an inspiration, the man saw, he saw, do you see, that the wrist is always moving, and a rotation weight in the watch, free to move with the wrist, could wind the spring, and so maintain a constant tension.

It SEEMS LIKE A LABOR-SAVING MECHANISM, and so it may be, if you call the winding of your watch a labor, but it is so only incidentally.

"It is, in the first instance, a quest for accuracy—and here we have a counterweight—you see how it's free to move?"

The boy looked down into the shoe box.

The old man's fingers extracted the piece and held it up to the light.

"I'm *telling* you," the man said, "that the contents of this box will one day be worth quite a bit of money." The man put the piece back in the box, pushed the box away, and shrugged.

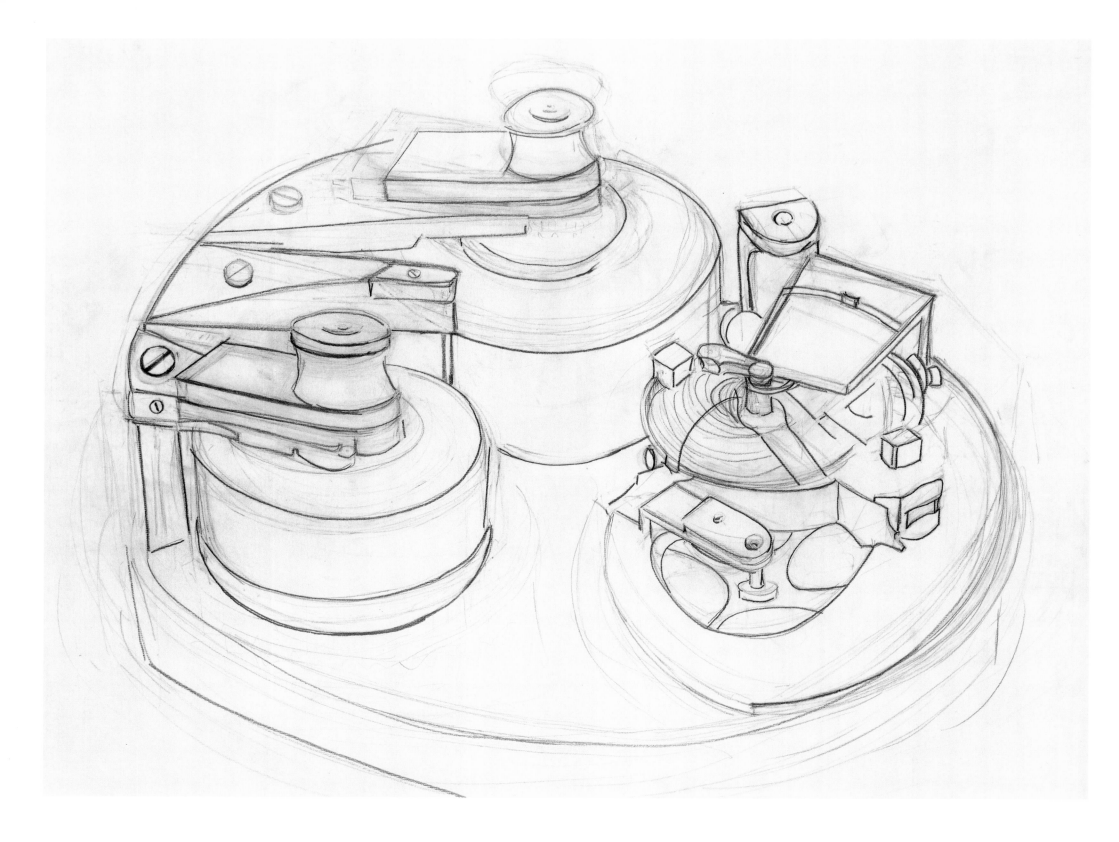

Marine Chronometer

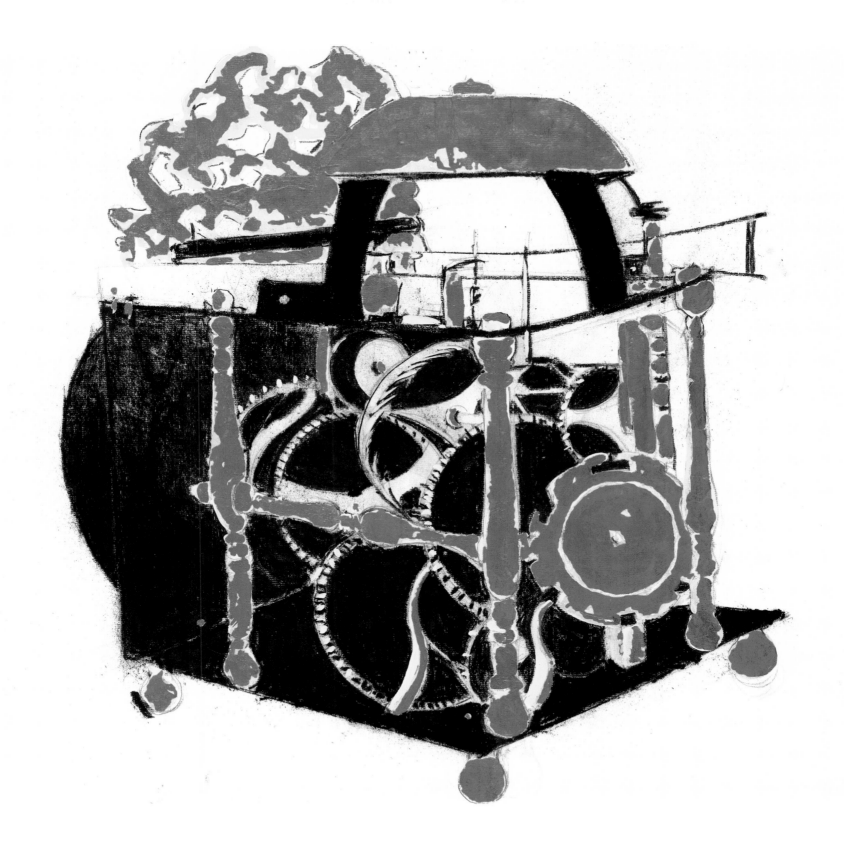

Dutch Clock with Verge Encapment

I HAVE BAD THOUGHTS," the boy said.

"There are no bad thoughts—your *thought* is as empty of moral meaning as the weather. It may be inconvenient, it may be appalling, it may terrify you, but it is not under your control. It exists, you see. And here are the things you can do with it: you can marvel at it; you can find a way to transform the seemingly inconvenient into your advantage; you can attempt to discern a pattern, the better to aid you to anticipate developments; or you can wait for it to change. At the least you can endure it, and find the strength in the notion that it has a purpose, though that purpose may be hidden from you.

"Moreover, that purpose may be, finally, *opposed* to your will — but it has a purpose.

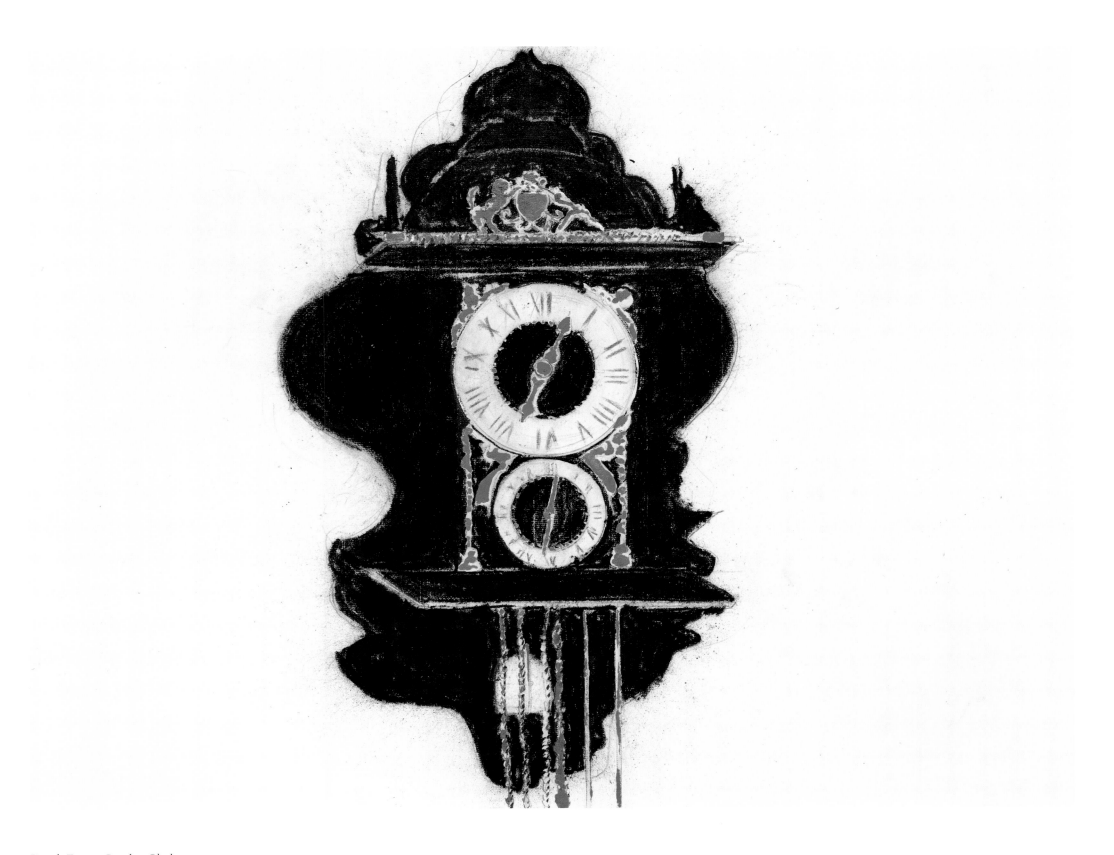

Dutch Zaanse Bracket Clock

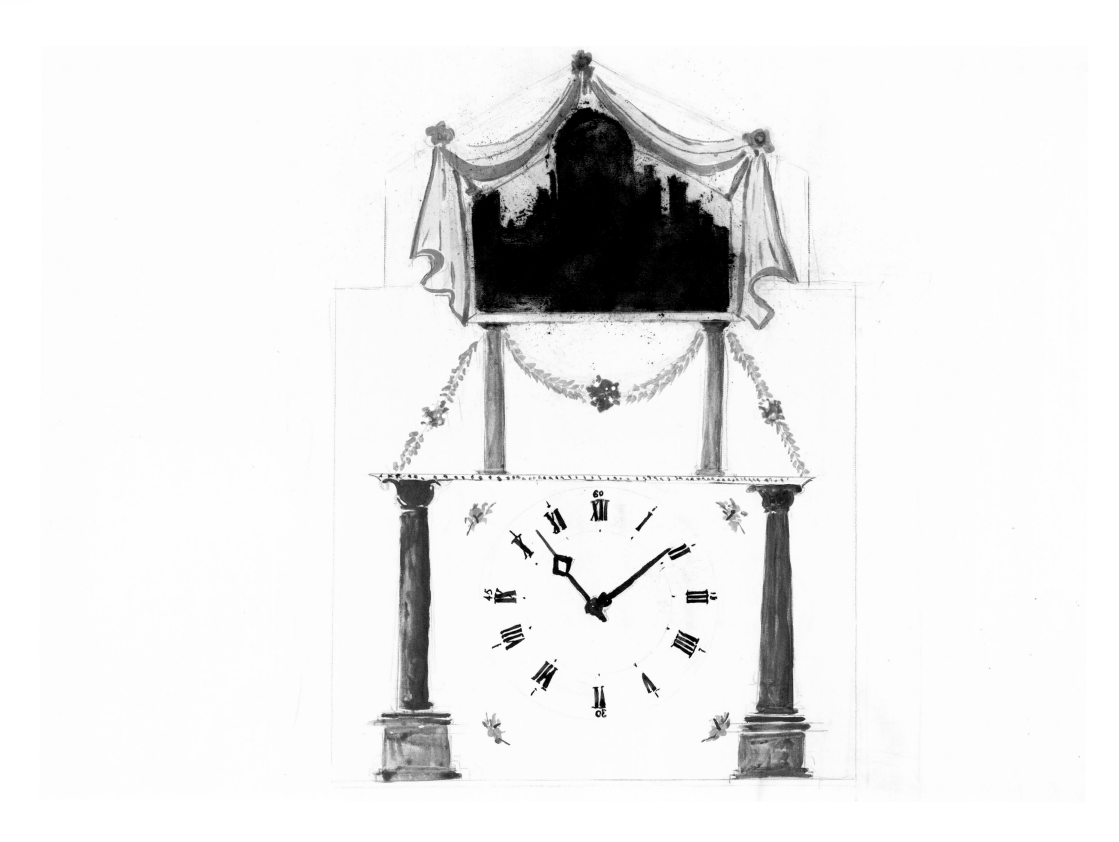

Theatrical Clock

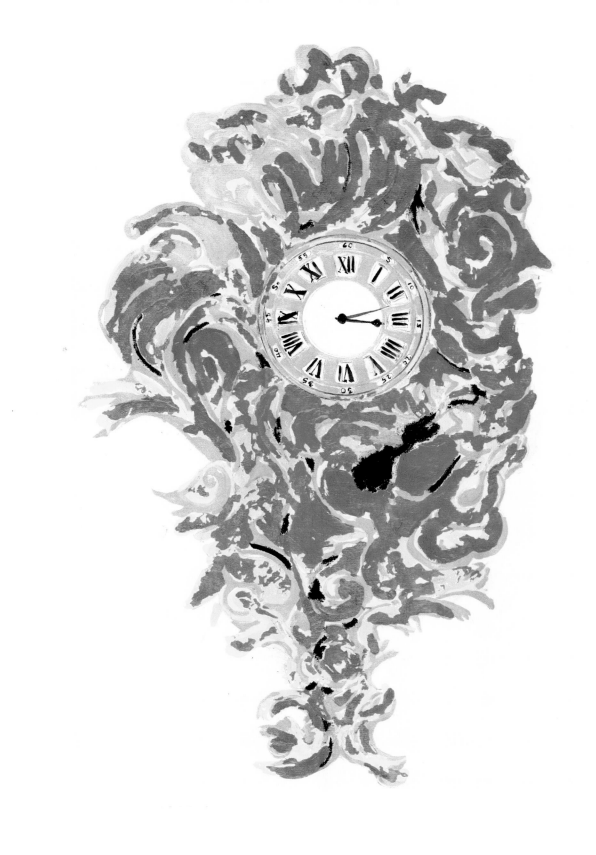

French Wall Clock

I KNEW A MAN, when we were in the East, who killed himself.

"He hanged himself.

"In one of the outbuildings of the labor camp. You see?

"He could not stand his thoughts.

"Now: I can't blame him—though the Torah says it is a crime.

"His *thoughts* were more than he could bear.

"Who could be disinterested enough to bear them dispassionately, saying, 'They have taken my wife, they have taken my children, they have taken my work, and driven me like a beast to this place, and soon . . . But I will look on and will strive to find a meaning in it?'

"We can find no meaning in it. This is not to say it has no meaning, but we are too close to it . . . too close to it.

Aɴᴅ ᴛʜᴇʀᴇ ɪs ᴀ ᴘᴏɪɴᴛ to which one's life has been shattered.

Like the tree, struck by lightning. And another might look on and say, 'The tree is gone.

Life, in its pursuit of its own ends, continues.'

"That it has a meaning," he continued. "*Sometimes* it cannot be borne."

He shrugged.

"Little is in our control. All is in the hands of God. The notion we can control our lives is an illusion. We do not control our lives. We live our lives.

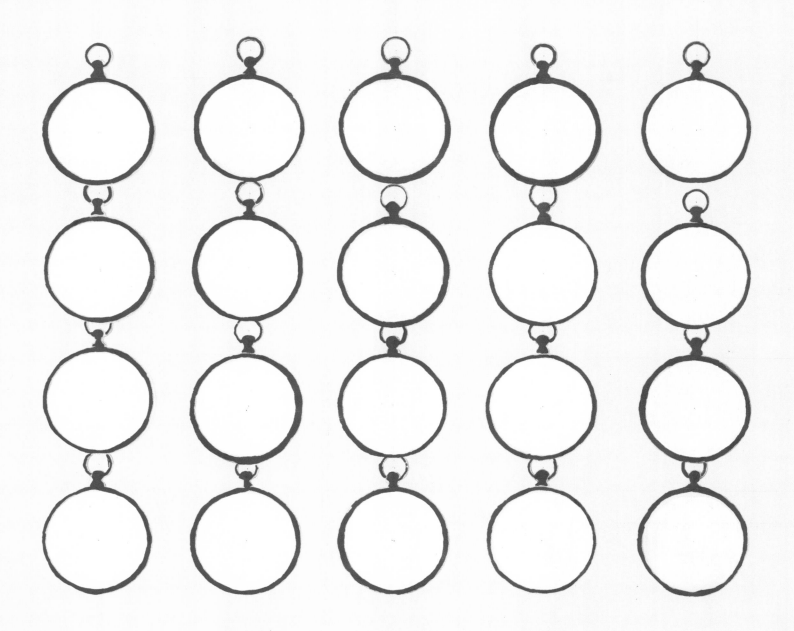

Pocket Watches

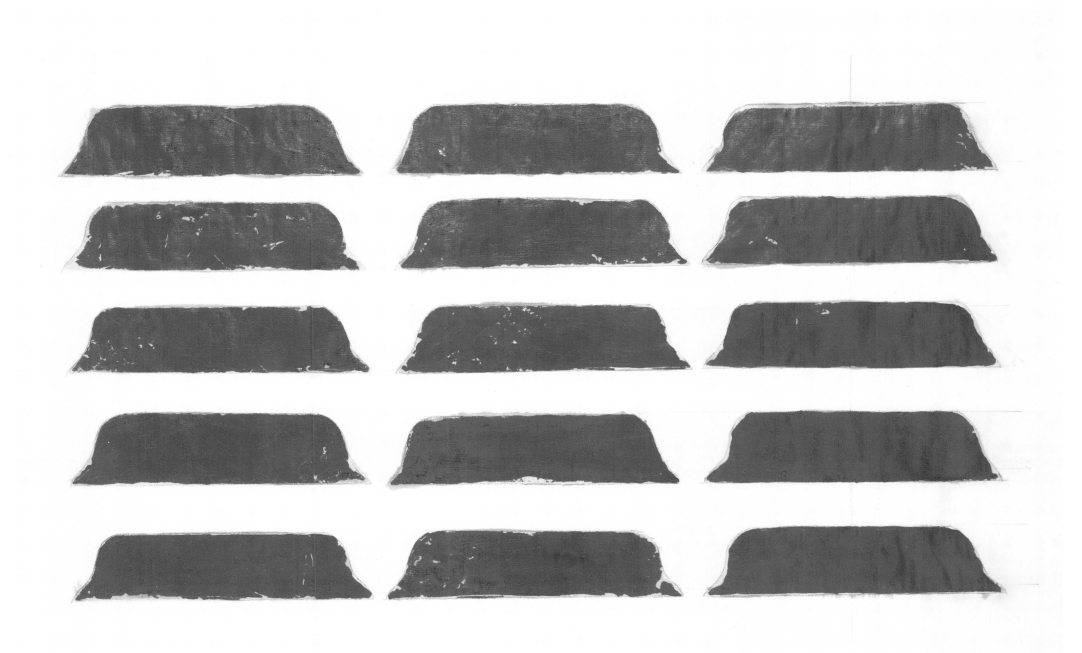

Ingots

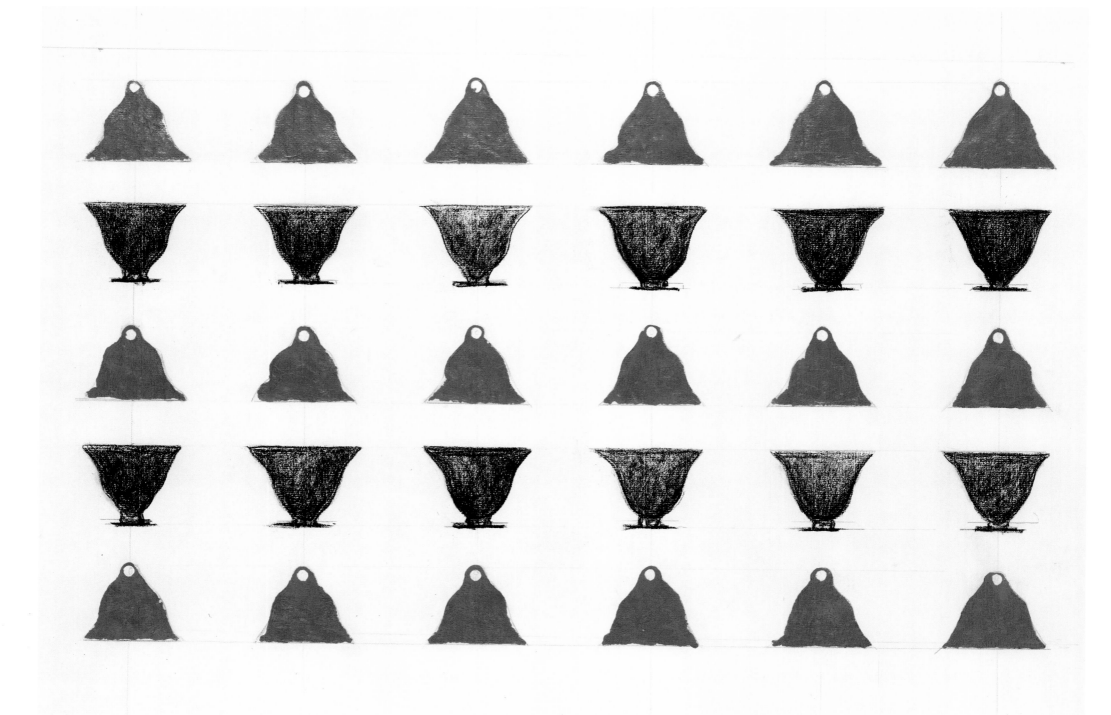

Cups and Bells

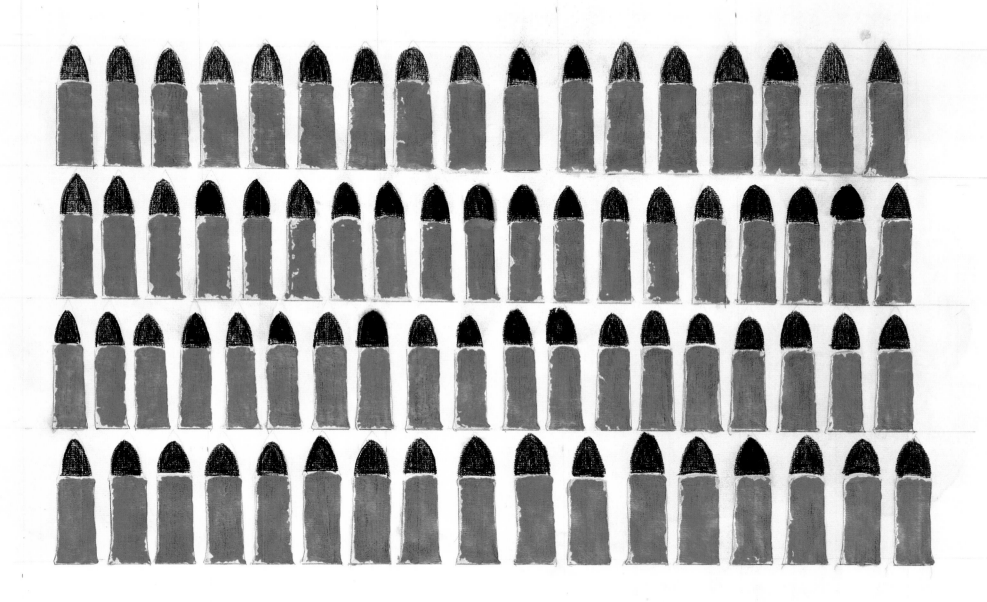

Bullets

Our THOUGHTS ARE LIKE everything else which exists. In the main, closed to us. We are not God, to wish otherwise—our task is to *strive* to understand, and function.

"The struggle, do you see, is not something which keeps you from your life—it is your life.

"The weak man says, 'I would be a philosopher, but I cannot, in the state I am in.'"

He smiled.

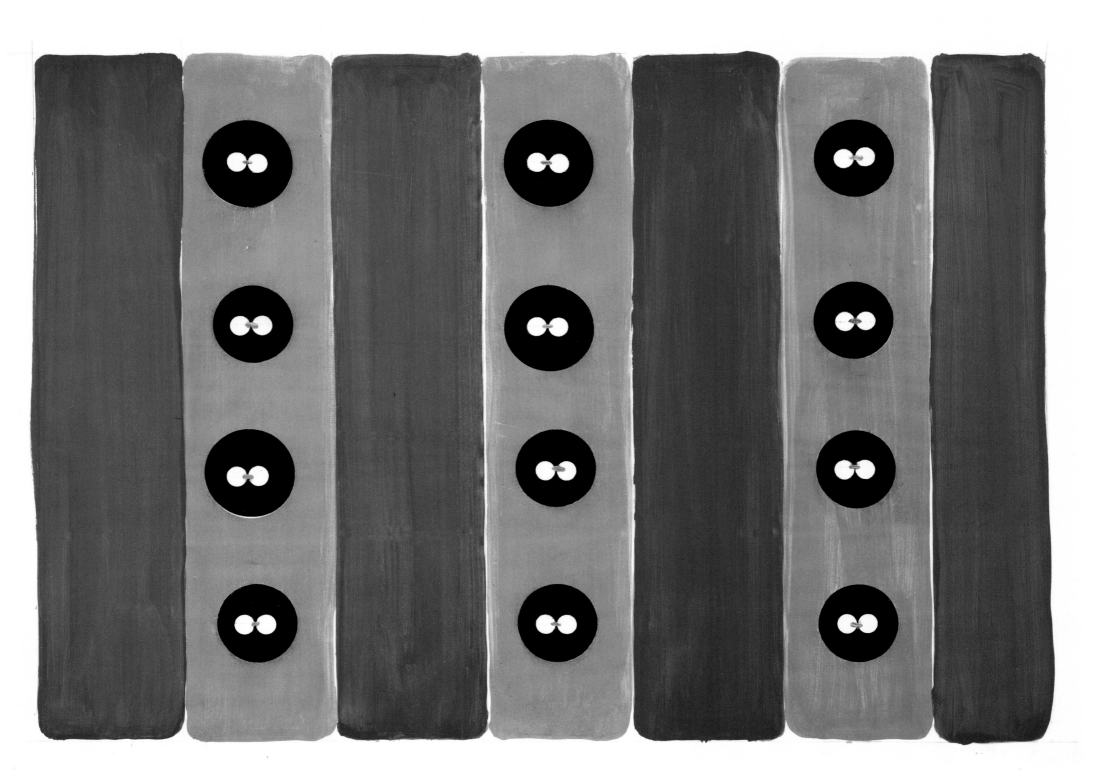

Buttons and Threads

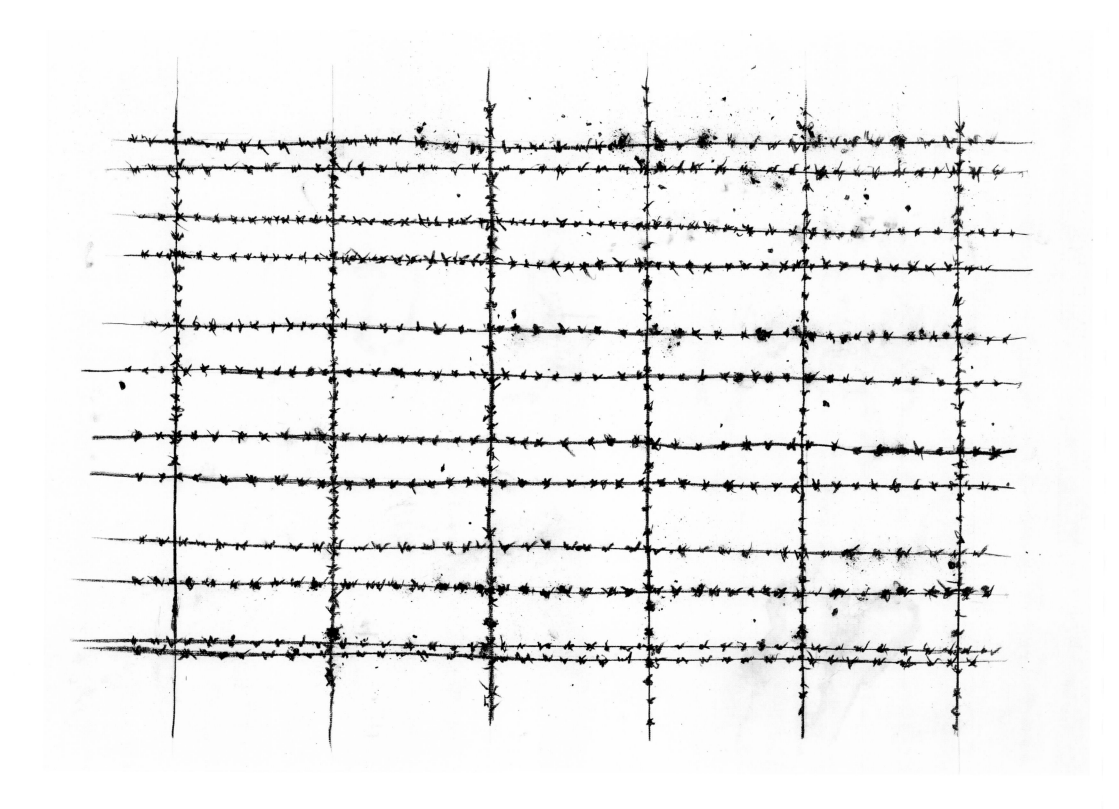

Barbed Wire

And so, I say the parts will be worth a fortune, after I am gone, but who is to say they will not fall into the hands of one who won't appreciate their value. . . ?"

"But I'd appreciate them," the boy said.

"Or that the world, which is changing quite rapidly, would not, as at some point it surely will, render them valueless even as a curiosity — did you know, at one point, in this country, the most attractive of investment enterprises was a system of canals, to haul freight from this point to that. And one day, a man invented the locomotive. That is the working of the world.

TODAY WE HAVE THE WATCH which runs on batteries, and keeps time to an accuracy never before imagined. But it is not *beautiful . . . and so . . .*"

The cadence of the Talmud Reader crept into his voice, and the boy smiled with love.

"And *so,* if we *determine* to cleave to the outmoded *technology,* how can we assert that the purpose of the watch is to demarcate time? It must have a second—a super—or a corollary purpose. Must it not? What would that purpose be?"

The boy thought a moment.

"To remind us of the past?"

THE PURPOSE OF ANY WATCH must be to remind us of the past; at least to the extent that we say it is to separate the past from the present—but you rightly see I quibble with the word. You mean to say it has worth as a souvenir—yes. As a souvenir of the invention and effort of the men who have gone before. And why should it not?

"The Arabs say 'baraka,' we say 'kavannah,' which may mean a similar thing in this usage.

"'Kavannah,' similar to 'Binah,' 'to understand.' What are your bad thoughts of?"

The boy said nothing.

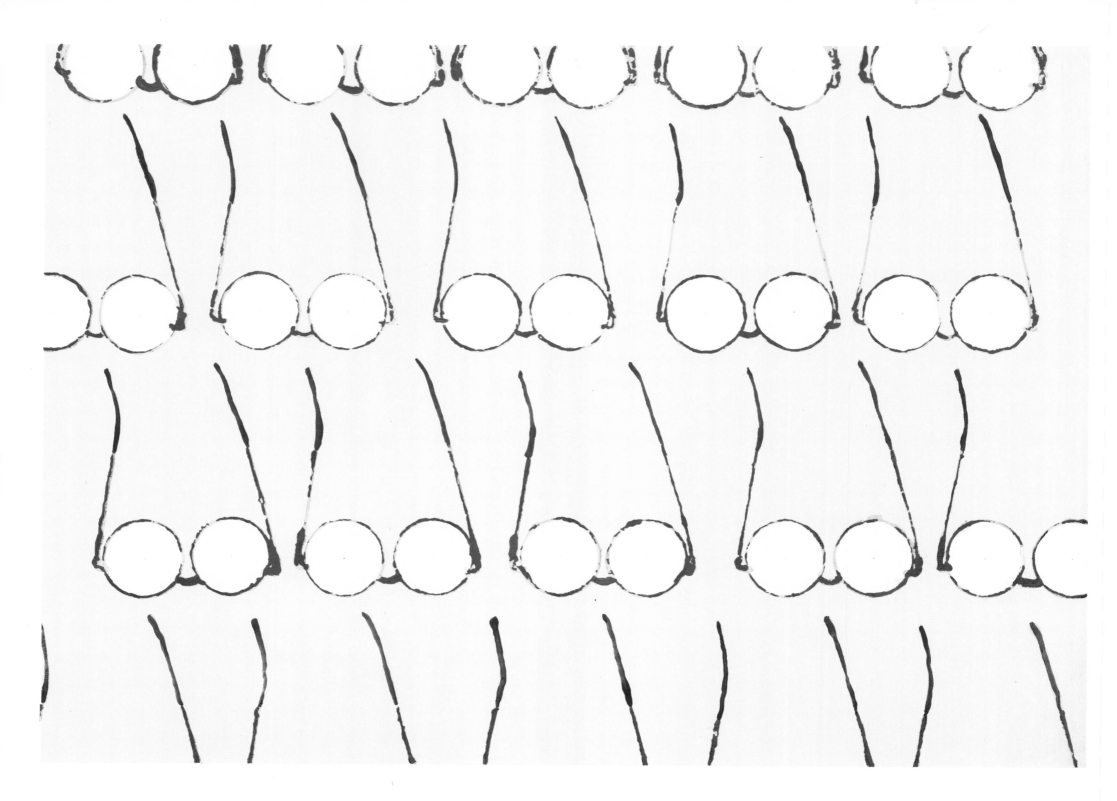

Glasses

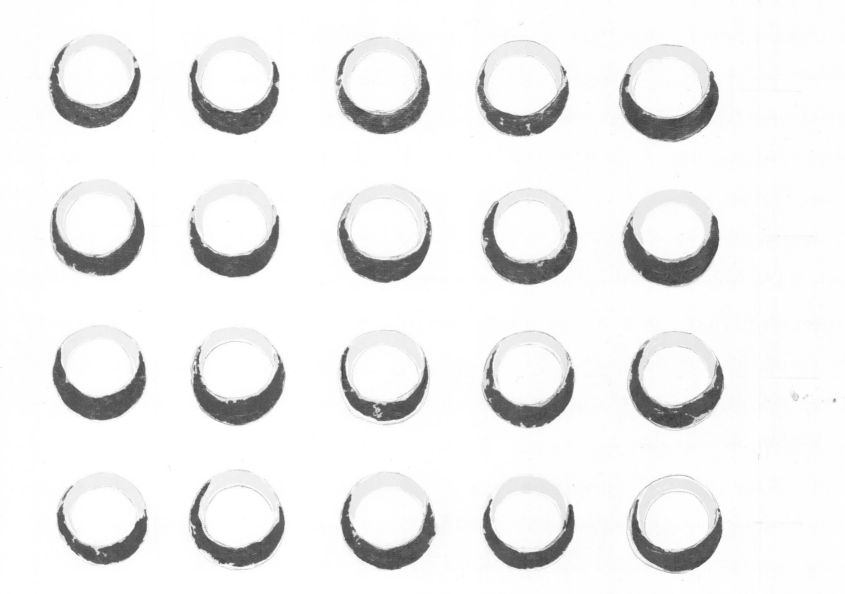

Wedding Bands

ALL RIGHT. Let's look for help where help may be found. What is your *parasha* they gave you to read?"

"Va-yeitzei," the boy said.

The man bobbed his head, to say, Well, there you are, then.

VA-YEITZEI YA'AKOV mi-Be'er Sheva . . . ,'" the old man said. And then he paused and looked up, as if listening a moment, then continued: "'Va-teiled ben, va-tomer: Asaf Elokim et-ḥerpati.'

"In which she says, do you see, that God has '*lifted* my reproach.' That Rachel, who did not abandon hope, has had a son. And she did *not* abandon hope. And, for that, for *that*, do you see, God removed her trouble.

"For, *finally* . . . ," the old man said, and then shook his head. "For my friend in the East abandoned hope, as many have done. And though we cannot blame them, we can do *otherwise*, and trust to God, and say, 'It has a meaning — at this time it is not for me to know.'

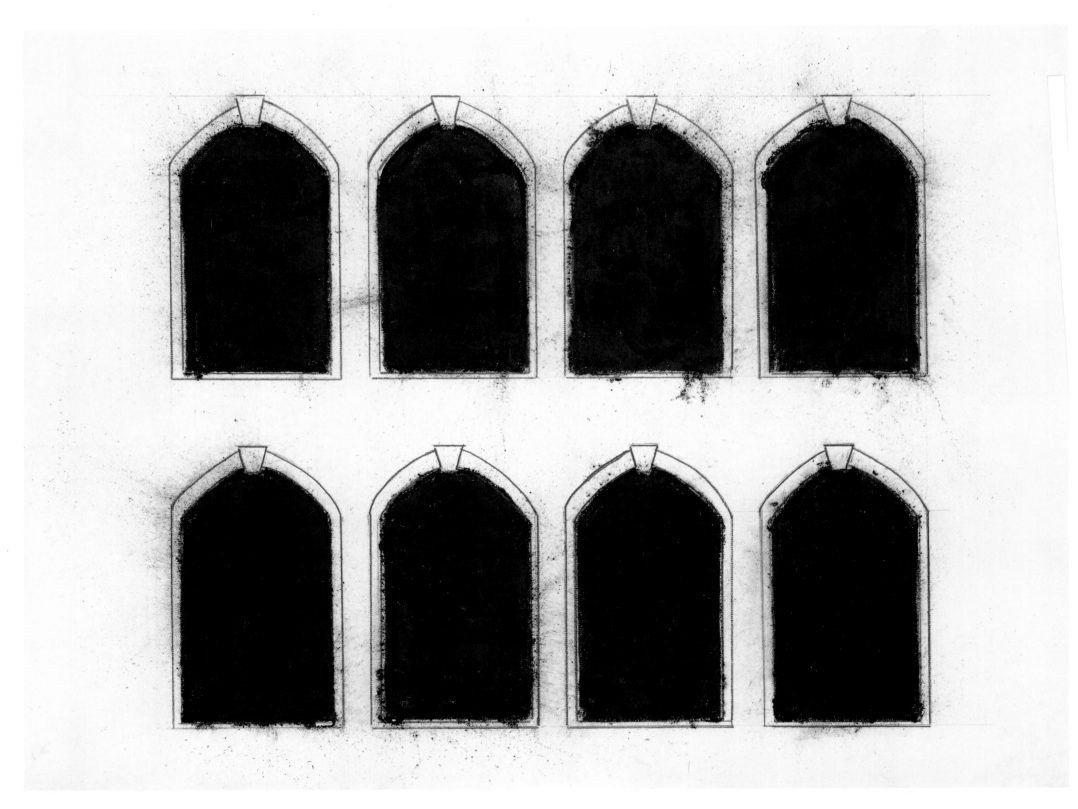

Windows

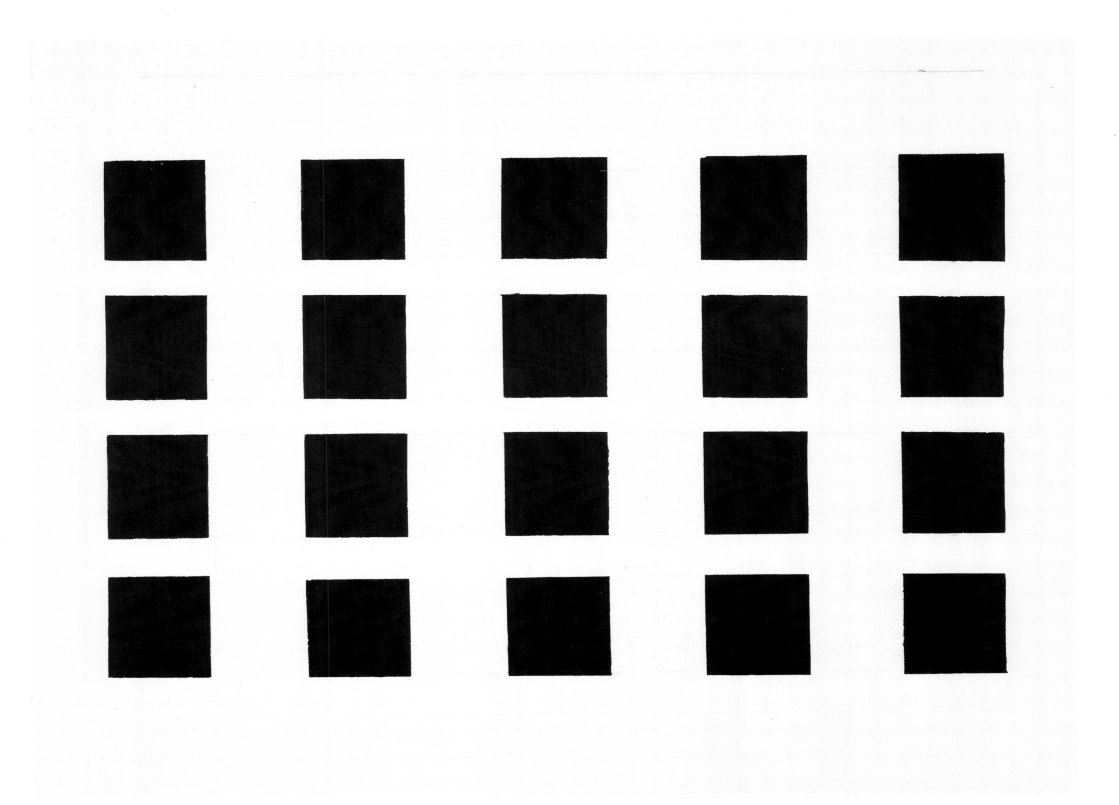

Windows

I WILL NOT ASK YOU what your thoughts are of, for that is not my business, though I will tell you nothing is more important to me than your happiness—but I will tell you that no thought you have has not been entertained by millions before you. That it is not in your control, and all that God requires of you is your actions. What you think and what you believe, what you feel are no one's concern.

"Not even God's, blessed be his name. Now, are you working with the Rabbi?"

"Yes," the boy said.

"What does he tell you?"

"To strive . . . ," the boy said, "to *strive* to understand how to be a good man."

The old man nodded.

"The Rabbi is wrong," he said. "It is not your concern to be a good man. No one can tell if he himself is a good man.

"Be a good Jew."

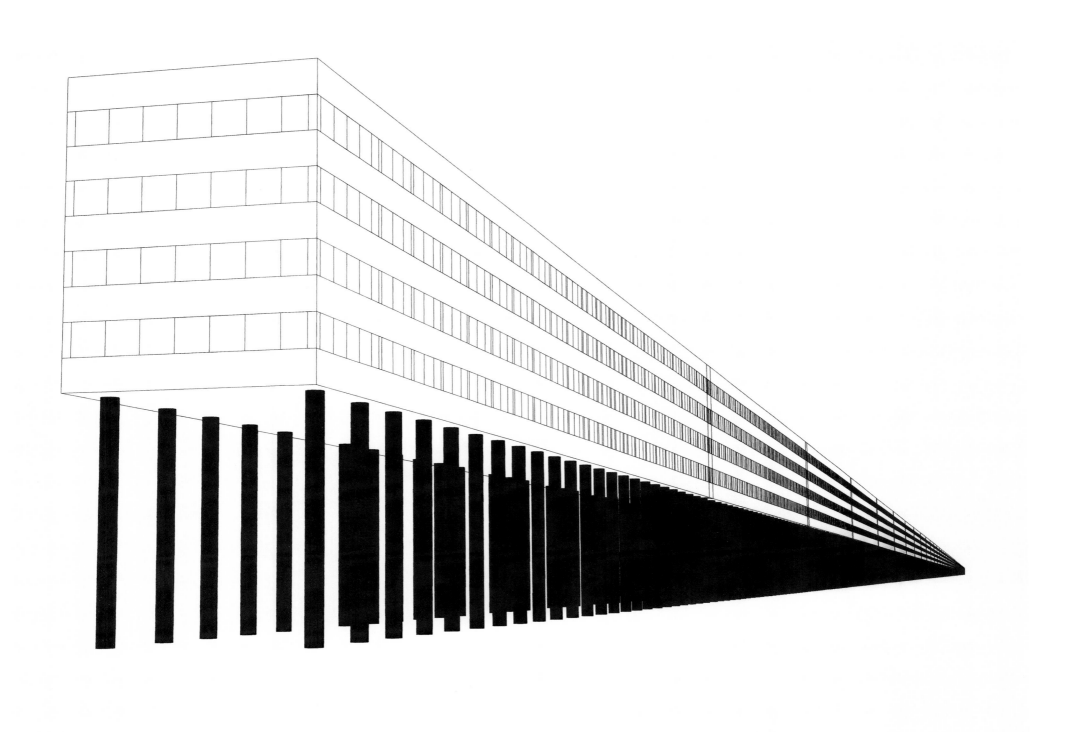

Postmodern Building

PLATE LIST

Captions by page number

6 *Topographical Instruments*
1998, 19" X 27", CHARCOAL, GRAPHITE, LATEX, AND GOLD LEAF ON PAPER

9 *Watches*
1998, 19" X 27", TEMPERA, GRAPHITE, LATEX, AND GOLD LEAF ON PAPER

11 *Watch Interior*
1998, 19" X 27", GRAPHITE, CHARCOAL, INK, LATEX, AND GOLD LEAF ON PAPER

12 *Synagogue Clock*
1998, 19" X 27", GRAPHITE, TEMPERA, INDIA INK, CHARCOAL, LATEX, AND GOLD LEAF ON PAPER

16 *Marine Chronometer*
1998, 19" X 27", CHARCOAL AND GRAPHITE ON PAPER

17 *Dutch Clock with Verge Encapment*
1998, 19" X 27", LATEX, CHARCOAL, GRAPHITE, AND GOLD LEAF ON PAPER

19 *Dutch Zaanse Bracket Clock*
1998, 19" X 27", CHARCOAL, LATEX, AND GOLD LEAF ON PAPER

20 *Theatrical Clock*
1998, 19" X 27", TEMPERA AND INK ON PAPER

21 *French Wall Clock*
1998, 19" X 27", LATEX, GOLD LEAF, AND INK ON PAPER

24 *Pocket Watches*
1998, 19" X 27", LATEX, GOLD LEAF, AND TEMPERA ON PAPER

25 *Ingots*
1998, 19" X 27", LATEX AND GOLD LEAF ON PAPER

26 *Cups and Bells*
1998, 19" X 27", LATEX, GOLD LEAF, AND CHARCOAL ON PAPER

27 *Bullets*
1998, 19" X 27", LATEX, GOLD LEAF, AND CHARCOAL ON PAPER

29 *Buttons and Threads*
1998, 19" X 27", TEMPERA, LATEX, AND GOLD LEAF ON PAPER

30 *Barbed Wire*
1998, 19" X 27", CHARCOAL AND FIXATIVE ON PAPER

34 *Glasses*
1998, 19" X 27", TEMPERA, LATEX, AND GOLD LEAF ON PAPER

35 *Wedding Bands*
1998, 19" X 27", LATEX AND GOLD LEAF ON PAPER

38 *Windows*
1998, 19" X 27", CHARCOAL ON PAPER

39 *Windows*
1998, 19" X 27", GRAPHITE AND TEMPERA ON PAPER

41 *Postmodern Building*
1998, 19" X 27", COMPUTER PRINTOUT

NOTE FROM DONALD SULTAN

With these drawings for *Bar Mitzvah,* I decided that rather than simply illustrating David's marvelous text, I would tell a parallel story as his story unfolds, one that serves as a visual and historical base describing the movement and casement of time. I chose gold for concrete reasons, and charcoal for symbolic reasons. Gold is the thread that binds together most of these drawings; their progression, a line leading the viewer from the age of the guilds to the modern day. Through these steps, I took a journey from the divine to the useful and back, I hope, to the divine. For hope is all we have. The future holds no certainty.

Bar Mitzvah has been

set in Centaur and Koch Antiqua typefaces

and printed on 157 gsm paper by South China Printing Company Ltd.

from film generated by Martin Senn.

Design by Jerry Kelly.